A Real Life Book

This Woman Deserves a Party!

This Woman Deserves a Party!

illustrated by MARY ENGELBREIT
written by TERRY LEE BILSKY

**Andrews McMeel
Publishing**

Kansas City

www.andrewsmcmeel.com

 is a registered trademark of Mary Engelbreit Enterprises, Inc.

98 99 00 01 02 RDR 10 9 8 7 6 5 4 3 2 1

Library of Congress Cataloging-in-Publication Data

Engelbreit, Mary.
 This woman deserves a party : Mary Engelbreit on motherhood / Mary
Engelbreit.
 p. cm.
 ISBN 0-8362-5203-9 (hardcover)
 1. Motherhood. 2. Mothers. 3. Family. 4. Engelbreit, Mary.
I. Title.
HQ759.E54 1998
306.874'3--dc21 97-26572
 CIP

Design by Stephanie Raaf

ATTENTION: SCHOOLS AND BUSINESSES
Andrews McMeel books are available at quantity discounts with bulk purchase for educational, business, or sales promotional use. For information, please write to: Special Sales Department, Andrews McMeel Publishing, 4520 Main Street, Kansas City, Missouri 64111.

A SWEET, NEW BLOSSOM OF HUMANITY, FRESH FALLEN FROM GOD'S OWN HOME TO FLOWER ON EARTH.

~ GERALD MASSEY

Contents

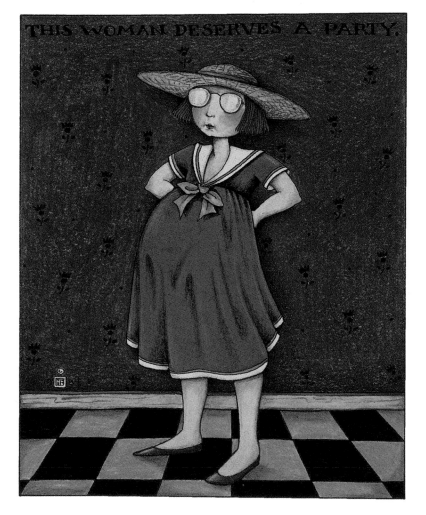

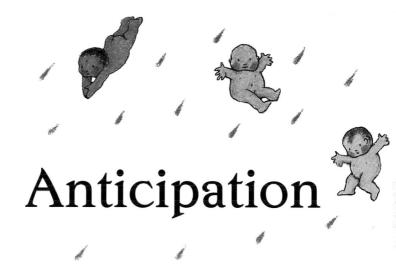

Anticipation

\mathcal{D}O YOU REMEMBER THE VERY FIRST MOMENT OF MOTHERHOOD? WAS IT watching a tiny heartbeat on a monitor, or listening to its resounding rhythm soar through your stomach? Or did you just know for sure that someone very special was growing inside? No matter where that moment took place, the one thing that all moms-to-be share are tears of joy in knowing they are embarking on a journey unlike any other.

Waiting for baby to arrive is the most amazing time in a mother's life, nine months filled with hopes and dreams, when the imagination is in full force. Who will the baby look like? If he is named

after his great great grandfather, does that mean he will look like him? In your dreams he may! When will the baby arrive? And for how much longer will your sleep be interrupted by those hiccups that are not yours?

It is often said that expectant mothers wear a glow for nine months, but if you look a little closer, under that glow is sometimes a pale shade of green. With all those hormones kicking in, it's not

Life is the first gift,
love is the second,
and understanding is the third.
—Marge Piercy

always the easiest time on a woman's stomach. But think of the plus side—you don't have to hold in your stomach for the first time since adolescence, and, in fact, you get to enjoy watching it grow! You may even learn to love the food stains your clothes acquire as the months go on.

There are so many millions of decisions to make in the most indecisive time in your life. Things that you never much paid attention to are now of monumental importance—for instance, choosing a stroller, birth announcement, or wallpaper for the nursery. When

The real secret
behind motherhood...
love,
the thing that
money can't buy.

Show your children
that you really
and truly *love* them.

—Anna Crosby

was the last time you stayed awake at night thinking about crib bumpers? Don't be alarmed if it takes several weeks, possibly months, to choose a crib. And what about sheets?

So, check off your list of things to do before the baby comes *before the baby comes* and keep that stack of books on "how to be a perfect parent" handy. Now is the moment to read them and find out all the answers. Put your feet up, relax, and enjoy this brief period of knowing where your child is at all times.

THE LAP of LUXURY

Sweet Baby

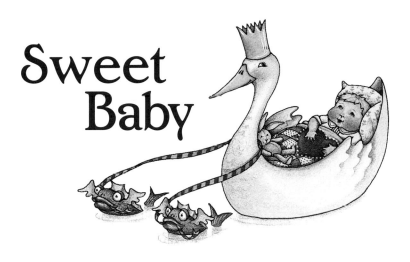

THE WAIT IS OVER AND FINALLY WE WELCOME THE LITTLE ONE TO OUR world! What a pleasure it is to meet the new baby. At last the long wait to hold, touch, and look at that beautiful face is over. Just smelling delicious baby smells makes all the waiting worthwhile! Looking at those tiny fingers and toes makes you wonder if there is anything more magical on this earth than a brand new baby.

*Babies are such a nice way
to start people.*

—Don Herold

Here are some things a new mother learns right away—crying is a good thing—it works for all kinds of needs. Mothers (and fathers) run from all directions at the sound of baby's new voice. Now is the time that early communication begins. When baby cries, parents listen. First, we pick them up from their cribs, if they happen to be alone. Then we try shifting positions, in case it's the way we are holding them. Parents learn quickly if baby doesn't like the bath—

baby lets us know! Why do they need a good scrubbing anyway, we ask ourselves, since they are carried around and fussed over all day?

Prayer of a New Mother

Let her have laughter

with her new little one;

Teach her the endless, tuneless, songs to sing,

Grant her the right to whisper to her son

The foolish names one dare not call a king.

—Dorothy Parker

Much to all new parents' delight, crying language is soon replaced with joy, coos, smiles, and laughter. Babies' whole bodies wiggle into a delicious smile when they see our faces or hear our voices. There is nothing more satisfying to new parents than that first smile or giggle. It will last a lifetime!

Parents are frequently reminded just how cuddly new babies are and how much they love to spend the evening on someone's shoulder. If baby is having a fussy night, we may find ourselves

walking them from one end of the house to the other until that magic moment when they settle down and snuggle on our shoulder. They breathe a little deeper and fall asleep right under our chin. We'll walk around the world just for that!

When the first baby laughed for the first time,
the laugh broke into a thousand pieces
and they all went skipping about,
and that was the beginning
of fairies.
—James Matthew Barrie

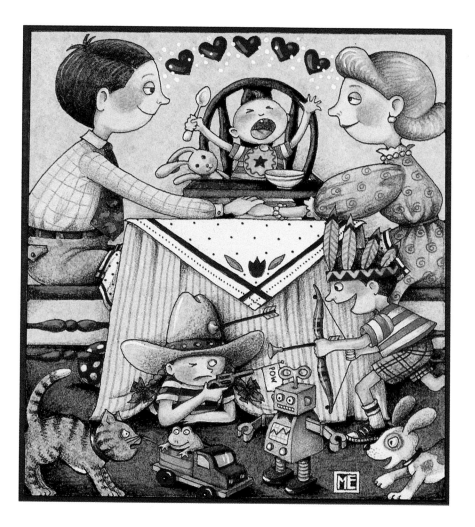

Watching the Family Grow

SOMETIMES YOU HAVE TO SNEAK IN AT NIGHT WHEN THEY ARE SOUND asleep and look at their little faces. They grow so fast that it's hard to realize that the face you are staring at is the same little face you delivered into this world. It's amazing that these little people can now talk and squabble and share their toys (or choose not to) with their friends and even siblings, as the family grows. Their presence in the house is noticed and changes everyone. Children have minds and wills of their own and if you doubt it, just challenge them and you'll find out!

· Manners ·

A child should always say what's true

And speak when he is spoken to,

And behave mannerly at table,

At least as far as he is able.

......

Parents are a special breed of grown-ups who are willing to forgo finished thoughts and conversations for the sake of raising their families. Sometimes you'll go for months without finishing a sentence. All parents understand this dilemma so you might be best off trying to converse with other people who have children. Don't be put off by distractions looming from all directions. If they have kids, they will understand your dangling conversation or know that all kids seem to need your undivided attention only when the phone rings. They will also understand your inability to remember who it is you were talking to in the first place.

Smile!

It's useful to live near someone who always has film and batteries in the camera. It makes recording life's special moments so much easier when you don't have to worry about where you left the camera last or which child may have been playing with it.

Try to see yourself in that small person creating a scene in the video store or a standoff at bedtime. And if indeed you were a perfect child who never did any of those things, blame it on the relative who is convinced your child looks just like them.

Surprise your spouse with special alone time in order to remember what you liked about each other in the first place. These are called "I remember you" or "B C" (before children) moments. Meeting for lunch, having dinner together in a restaurant, or taking a walk on the beach are all good examples of "I remember you's." Try spending a whole weekend alone from time to time. It's an opportunity to re-group, re-connect, and race home to the children as soon as possible!

Out of the strain of the doing
and into the peace of the done.
—Julia Louise Woodruff

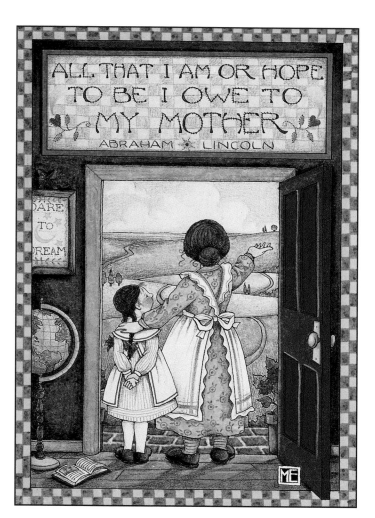

ALL THAT I AM OR HOPE TO BE I OWE TO MY MOTHER

ABRAHAM ✷ LINCOLN

Let's Hear It for Mom

WHENEVER A MOM IS CREATED, THERE ARE CERTAIN SUPER-HUMAN ingredients that go into the mix. No one person explains to you how to do things that you never did before. Somehow, someway, you reach inside and what you need is there. You will find yourself capable of going on cold coffee and very little sleep after nights of toothaches, bellyaches, and earaches. Not to mention bad dreams. You have to be there to listen to those, too. And what about the tooth fairy? Did you ever forget? Probably not. Where did you learn to spread peanut butter on soft white bread without making holes? Did

you ever think you might be so good at it that you earn a permanent position filling lunch boxes for a minimum of eight to twelve years?

You are the person who can look into your child's eyes and know when there is something wrong. You feel certain they have a fever without reading a thermometer, and you're the first to know when they've had a bad day at school.

They always looked back
before turning the corner,
for their mother was always at the window
to nod and smile,
and wave her hand at them.
Somehow it seemed as if
they couldn't have got through
the day without that,
for whatever their mood might be,
the last glimpse of that motherly face
was sure to affect them like sunshine.

—Louisa May Alcott

Where did your X-ray vision come from and why is it that you know exactly what is missing from the refrigerator for breakfast? And how about the internal beepers that alert you when your house is too quiet? You are never too tired to praise your child for a job well done and you encourage hugs and kisses at all times of the day and night. There is one name for you, and it's the one you love to hear the most—

Mom!

And so our mothers and grandmothers have,
more often than not,
anonymously handed on the creative spark,
the seed of the flower they themselves
never hoped to see—
or like a sealed letter
they could not plainly read.
—Alice Walker

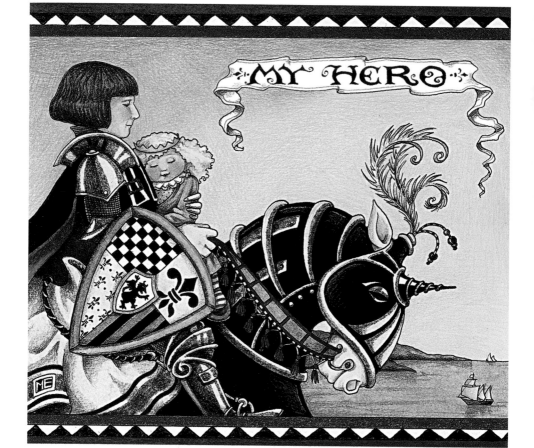

Dads in Shining Armor

IT'S YOUR TURN, DAD, TO TAKE A BOW—HERO, PROTECTOR OF CHILDREN, and knight in shining armor. You have a lap large enough to hold your children and arms long enough to reach out to them at the same time as you hug their mother. They love to be with you, whether it's on your shoulders (can you feel small feet kicking into your chest?) or in your bed for an early morning cuddle. Have you been awakened to the feel of tiny fingers pulling on your chest hair? Somehow, it's the first thing they reach for as they hoist their sleepy bodies onto your bed.

A man finds out what is meant
by a *spitting image*
when he tries to feed cereal to his infant.

—Imogene Fey

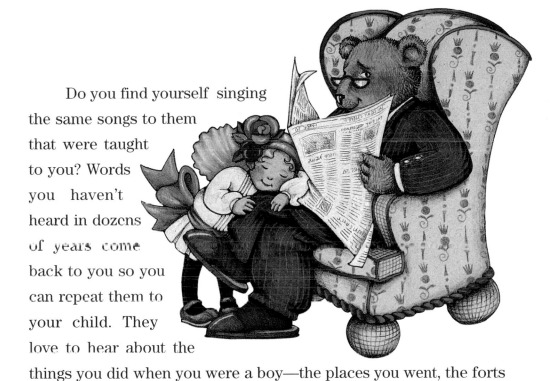

Do you find yourself singing the same songs to them that were taught to you? Words you haven't heard in dozens of years come back to you so you can repeat them to your child. They love to hear about the things you did when you were a boy—the places you went, the forts you built, the games you liked to play.

Alone time with Dad is so very special. Read to them even after they know how to read. They love to hear the sound of your voice, and you bring so much to the story, especially if it's one that you remember from childhood.

Take them on an adventure, which can mean lots of things: having breakfast out while mom sleeps in, driving through a carwash, going to the library together, or taking a walk in the woods.

Children assume that their Dad knows everything; with that kind of endorsement, why not enjoy as much time together as you can?

I've wondered, over the years,
as I've recalled these moments with my father,
what they're supposed to teach me about life.
I can't say there's any lesson,
except the sheer pleasure of his company,
which was a great gift,
and which I gather is sometimes hard to come by,

between fathers and sons.

—Scott Simon

When a child is born, so is a grandmother.

·ITALIAN PROVERB·

Aren't Grandparents Grand?

*L*ET'S HEAR IT FOR OUR PARENTS WHO SHOWED US THE WAY. NOW IT'S their turn to have little ones around them again. Only this time, they don't have to worry about mistakes they might make. They are free to indulge rather than discipline, serve an extra sweet or two if they feel like it, and offer another lap for children to climb into. Somehow they don't seem to mind accumulating toys in their homes, adding a crib and a high chair, and decorating their refrigerator for the first time in years.

Grandparents are always there for special events—birthdays, holidays, class plays, and recitals. But they also make any day special by hosting tea parties, sleepovers, or taking a grandchild to lunch. Showing tiny fingers how to cut cookie dough is a way of making memories. So are the raisin faces made in hot cereal and peanut butter and jelly sandwiches cut into fishy shapes. It's often the little things that grandchildren appreciate and remember the most.

The same can be said for grandparents. Just watch them melt when grandchildren give back their hugs, sing songs that were sung to them, and call them that special name that no one else can. No matter how many grandchildren they are blessed with, each one earns a particular place in their heart.

We should all have one person who knows
how to bless us despite the evidence,
Grandmother was that person to me . . .
—Phyllis Theroux

SO MUCH OF WHAT WE KNOW OF LOVE WE LEARN AT HOME

Teach
Your
Children

SOMETIMES TEACHERS ARE PARENTS, BUT PARENTS ARE ALWAYS TEACHers. It is through their parents' eyes that children are introduced to the sounds and sights of our world. It takes two large hands to show two tiny ones how to clap, wave goodbye, tie shoelaces, water the flowers, pet a kitten, buckle up for safety, and wash before dinner.

♥

The mother's heart is the child's schoolroom.

—Henry Ward Beecher

Did you ever hear your child say something that did not bear repeating? Did it sound just like something you would say, using your tone of voice? That is when we know how powerful our voice is—they really do see and hear everything we say! You couldn't wait for them to learn how to talk but now you have to remind yourself that someone is always listening to you.

Since the most important lessons are learned at home, let's not forget to instill interest in ladybugs, fireflies, seashells, and sand castles. Provide crayons and paint brushes for small fingers to express themselves and

remind them they don't have to color within the lines. Invite messy hands to help in the kitchen and let them make their own cookies and piecrust. Show them how to catch a ball, ride a wave, build a snowman and find the big dipper in the sky. Keep a trunk filled with costumes and let them entertain you with their stories and skits. Watch their imaginations soar!

It's the little things you do
day in and day out **that count.**
That's the way
you **teach your children.**
—Amanda Pays

45

When children listen to their parents read, and grow up with lots of books in their home, they begin to appreciate the beauty of books. They learn how to entertain themselves by turning the pages of a favorite story. Sometimes they just need to see the pictures over and over again. But when you hear them tell you that you skipped a line, you know you have done your job well!

My mother told me stories all the time . . .

and in all of those stories

she told me who I was,

who I was supposed to be,

whom I came from,

and who would follow me.

In this way, she taught me the meaning

of the words she said,

that all life is a circle

and everything has a place within it.

—Paula Gunn Allen

Civilized Siblings

ALL PARENTS SEEM TO AGREE THAT THERE COMES A TIME WHEN THEIR child begins to walk and talk and suddenly all they can think about is having another one. What mother doesn't look longingly at a new infant in a snugli, or at the clothes her child has outgrown, and want to see a new little one in them. Is it really time to put away the crib now that your big boy can climb out of it? Along with recognizing your toddler's struggle for independence comes a longing for the days when a tiny baby snuggled on your shoulder and all you could hear was the sound of him breathing—before he learned to say *No!*

"I think he should sleep in the garage!"

That's what one of our friends said about her new baby brother. All the fussing over a new baby brother was more than she could handle at three years old. She didn't like to hear him cry and wasn't much interested in sharing her room with him. That was before she had to worry about sharing her toys.

A sister or a brother is a present our parents give to us. They are the means by which we learn to forge friendships, settle disagreements, share secrets, and mediate matters of interest. Negotiations can include but are in no way limited to possession of a favorite key

Mine!

Mine!

chain that appears to have no intrinsic value whatsoever except for the fact that it is also known as *mine!* MINE is a word that older sisters and brothers learn very quickly and it applies to every item, starting with the crib, that was in their bedroom before the newest member of the family arrived. Parents of two or more children live by certain heretofore unwritten laws: It's safer to buy three red sippy cups than one of each color; M&M's must be counted before being distributed; an infant's bedtime is often later than a toddler's, and this can cause havoc in a home; if you remove the front passenger seat from your car and leave it on your lawn, then any child who wants to can sit in it.

Upon the arrival of a new sister or brother, the older sibling is urged to remove the crown from the top of his head and hand it over to the younger member of the family. Along with the changing of the guard comes a friend for life, someone to share your most intimate thoughts with. Siblings can grow together and keep each other company. They can share experiences in a way that sets them apart from even the closest of friends. As the years go on and they become friends for life, they provide a certain harmony in

each other's lives. An early morning conversation with each other and the rest of the day feels good and right. Siblings can spark something in the other and bring back a memory from a magical time. Friends may come and go but there is no bond quite like a sister or brother—they are there for the good times and the bad, as well as the ones in between.

We acquire **friends**
 and we make **enemies**
but our sisters
 come with the territory.
 —Evelyn Loeb

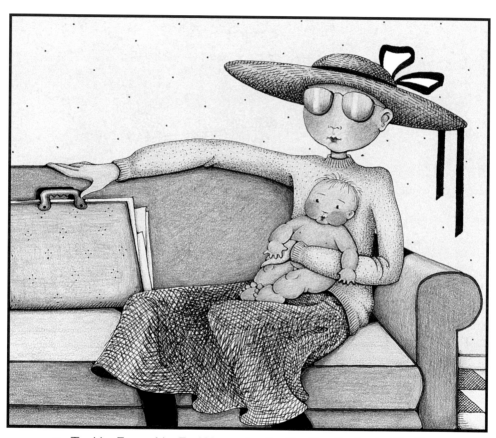

• THE NEW ASSOCIATE •

Every Mother Is a Working Woman

ARE YOU SOMEONE WHO CAN ANSWER A PHONE CALL WITH ONE HAND, serve breakfast with the other, kick the dishwasher closed with your leg, and try to remember where you placed your cup of coffee? Are the lunches packed? Is the school bus here yet? Is your motor running? Did Katie forget her homework? Did you forget yours? Is that a run in your pantyhose? Where is your coffee? Did you check the microwave? Oops—it's too hot! Did anyone walk the dog this morning? Did you remember to pay the bills last night? Did someone forget their soccer shoes? Where is your coat? It's time to go to work!

· Okay ·

I'm in charge here.

Every mother is a working woman who is the head of the board of directors in her home and may or may not moonlight in another position outside of the home. She jump-starts her day with soggy cereal and cold coffee and calls it breakfast. She is capable of wearing several hats at the same time and willing to go from one full-time job to the next without a break in between. When she arrives home in the evening, she kicks off her shoes and slips into second-grade math. No matter what emergency is taking place in her office, she stops dead in her tracks at the sound of her

child's voice on the phone. She is convinced that there is never enough time in the course of a day. She knows exactly what she needs to make her life run smoother, to be certain that every detail is taken care of, that every child of hers is fed, bathed, read to, and their homework is completed on time.

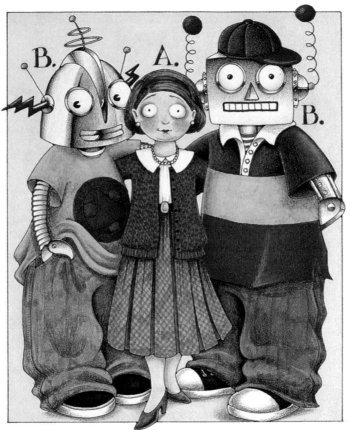

A. THE MOTHER. B. ALIEN TEENAGERS

THIS TOO SHALL PASS

Alien Teenagers: The Final Frontier

So the little red Keds have been replaced by the largest black sneakers you have ever seen and suddenly you realize that you have the smallest foot in the family. How did this happen? The same little hands that folded inside of yours are now bigger than your hands. You just noticed the size difference when you were given a "high five" for buying the baggiest jeans you could find. You knew that if the jeans wrapped around your waist, twice, they were the right size for your teenager. And look how they match their oversized, stained T-shirts and baseball caps.

You start your car engine and the loud music sends a jolt through your body. You pick up the soda cans and food wrappers, check the gas meter and discover you barely have enough fumes to get you to the supermarket. You have to get to the supermarket because there is nothing left to eat in your home. The refrigerator seems to empty itself along with the gas in your car, the soap and shampoo in your bathroom, and the special conditioner you bought for your hair. Is that glittery blue nail polish on your steering wheel? What is your jacket doing in the car?

Are you ready to reclaim your conditioner, your car, and your clothes? Do you want to have your life back? Are you tired of taking phone messages for someone who can't do the same for you? Are you getting used to the magenta hair dye in your kitchen sink? Do you want to throw away the television and the stereo?

Never lend your car
to anyone to whom you have given birth.
—Erma Bombeck

Remember that this is just a phase. We all went through it and perhaps we see some of our own rebellion or adolescent angst in our kids. We want to spare them from making mistakes but we know better. And it's hard to see eye to eye with someone who is taller than you and doesn't want to be seen with you. So take a deep breath, relax, and remember that this too shall pass . . . all too quickly.

How many hopes and fears,
how many ardent wishes
and anxious apprehensions
are twisted together
in the threads that connect
the parent
with the child!

— Samuel G. Goodrich

.

TIME FLIES

WHETHER YOU'RE HAVING FUN OR NOT.